MW00794927

WORDS FROM A FASHION ICON

COCO CHANEL

For Martina Granolic,
who adores black just as much
as Coco Chanel herself.

WORDS FROM A FASHION ICON

COCO CHANEL

Megan Hess

Hardie Grant

BOOKS

Contents

Introduction

In my work as a fashion illustrator, I have loved studying the wisdom of Gabrielle 'Coco' Chanel, whose creative vision and determination have much to teach all of us. From her difficult childhood as an orphan, to building one of the world's most iconic fashion brands, her life was truly astonishing.

Little Gabrielle was born in 1883 in Saumur, a medieval market town on the Loire River in western France. When Gabrielle was 12 years old, her mother died, and she was left at a convent-run orphanage in the village of Aubazine. The austere aesthetic of the convent, and the black, white and grey palette of the nun's habits, stayed with Gabrielle and influenced her work in years to come.

At the convent, Gabrielle learnt to sew and eventually she found work in a draper's store in the town of Moulins. In the evening, Gabrielle performed as a cabaret singer at La Rotonde entertainment pavilion. This is where she became known by the nickname 'Coco', which stayed with her for the rest of her life.

Aged around 20, Coco met a handsome ex-cavalry officer named Étienne Balsan, who was a textile heir and racehorse breeder, with money and powerful connections. The two became lovers and Coco lived with him at his estate in Royallieu, where he kept racing stables. It was here that she first began to wear tailored jodhpurs, a dramatic step away from the frills and corseted skirts fashionable women wore at the time. Instead, she added elements of masculine-wear, developing a chic sporting style that was to become her own.

At Royallieu, Coco met Arthur 'Boy' Capel, a rich British socialite with whom she fell in love. Even after he married, she felt he was her true love, and was heartbroken when he died, tragically, in a motorcycle accident.

Coco aimed to set up her own millinery business and both Balsan and Capel supported her endeavours. Balsan had a bachelor apartment in Paris where he let her set up her boutique on the ground floor. Soon, Capel lent her the money to buy her own premises – at 21 Rue Cambon. It was in the heart of Paris haute couture, and Coco soon gathered a loyal following of Parisian socialites.

Coco's designs were simple, elegant and chic. She pared back the frills and complicated ornaments that weighed down early twentieth-century fashion. Her business was highly successful, and she opened several stores. One of these stores was in Deauville, a French seaside town, where she holidayed regularly with Capel. She was inspired by the recreational and sporting wear worn on the beaches and the tennis courts to create clothes that women could move in comfortably.

It's here she created the *marinière* – using the white-and-blue Breton stripe worn by local sailors – in a chic women's blouse. She also began to use jersey, a fabric that had previously mostly been used to make men's underwear. She tailored it for women, and it was a hit.

Eventually, Coco was able to buy the entire building nearby at 31 Rue Cambon, with its gorgeous mirrored staircase leading up to her design studio. The world was in love with Coco Chanel. She met the rich and famous, including the composer Igor Stravinsky, and the painters Salvador Dalí and Pablo Picasso.

Coco had other partners in her life, including the poet Pierre Reverdy and Hugh Grosvenor, the second Duke of Westminster, who pursued her for years but whom she refused to marry. It is through borrowing the duke's sports coat that Chanel was inspired to work with tweed. Her tailored tweed suit was first released in 1925 and became signature of Chanel's style. It is still a part of the brand today.

Coco revolutionised the world's relationship with black. In 1926, at a time when black meant mourning, Chanel released her little black dress, and it took the world by storm. Black and white were a core palette for Coco. She loved to wear black with a great string of pearls, and often worked with her dressmaker's scissors dangling from the pearls.

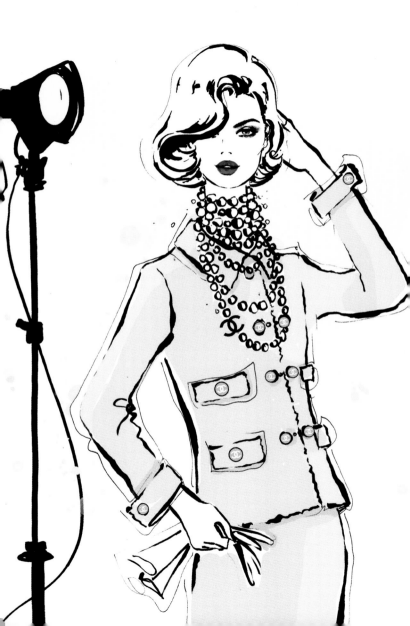

She resisted lures from Metro-Goldwyn-Mayer in Hollywood for years but eventually agreed to bring her Parisian style to the silver screen. She dressed stars like Elizabeth Taylor, Greta Garbo and Marlene Dietrich. Marilyn Monroe told reporters that the only thing she wore to bed was a few drops of Chanel No. 5, Chanel's wonderful signature perfume, a scent that still lingers in 31 Rue Cambon today.

Coco lived across the street from 31 Rue Cambon, in her rooms at the Ritz hotel. During the Second World War, she declared, 'This is no time for fashion,' and closed 31 Rue Cambon. She lived in the Ritz with her partner, an officer in the German army. After the war, Coco moved to Switzerland and didn't work for 14 years.

In 1954, Chanel made a comeback and reopened 31 Rue Cambon. Initially, her designs received mixed reviews, but eventually she won back the heart of the fashion world. Coco worked hard until the day before she died – passing away peacefully in her sleep in her bed at the Ritz.

Gabrielle 'Coco' Chanel was strong and provocative with a vivid sense of self. In many ways, she broke with tradition and she changed how we dress. She was a brilliant businesswoman who rose from poverty to associate with members of the aristocracy and the artistic elite, and to create one of the world's most luxurious brands. Coco Chanel was no stranger to heartbreak and life gave her the kind of wisdom that sits within these pages: brave, inspiring and, above all, elegant.

Megan Hess

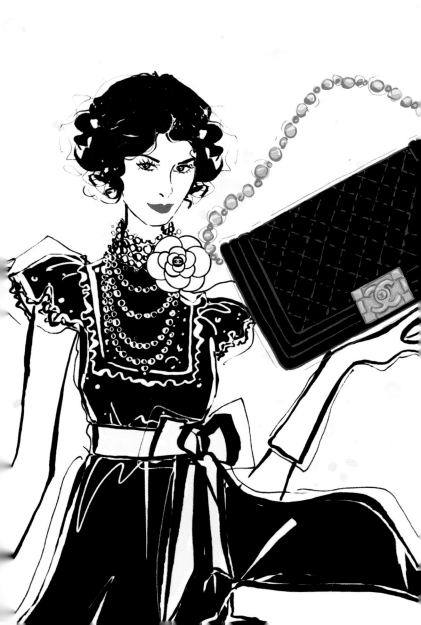

On
fashion

Coco Chanel changed fashion. She revolutionised our relationship with the colour black and reinterpreted some masculine styles as a new kind of feminine elegance. She moved among the elite but came from a world of poverty. In some ways, Coco was deeply unconventional. She was both an outsider and an insider, which gave her a broad perspective on fashion's place in society.

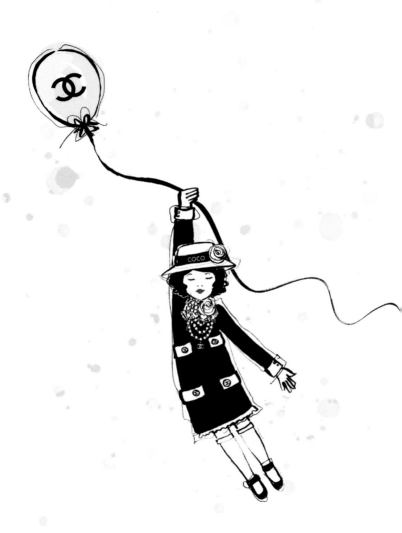

Fashion does not exist only in dresses; fashion is in the air, it is borne on the wind, you can sense it, you can breathe it, it's in the sky and on the highway, it's everywhere.

Fashion fades,
only style
remains
the same.

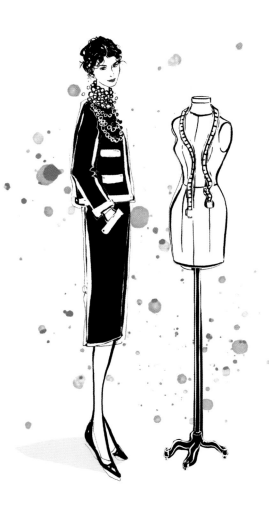

A *dress* is
neither a tragedy,
nor a painting;
it is a *charming* and
ephemeral creation,
not an everlasting
work of *art.*

With a pullover and 10 strands of *pearls*, she revolutionised *fashion.*

**CHRISTIAN DIOR,
FASHION DESIGNER**

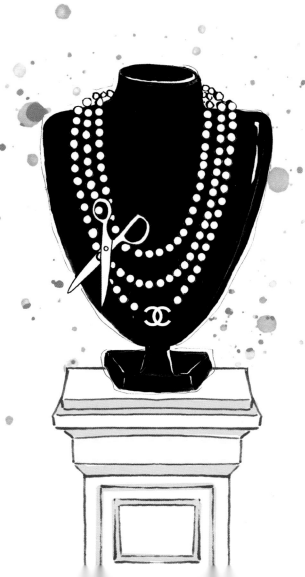

No one is
powerful enough
to be **more**
powerful than
fashion.

I shall dress
thousands
Of women.

A girl should
be two things:
classy and
fabulous.

Adornment,
what a *science*!
Beauty,
what a *weapon*!
Modesty,
what *elegance*!

On choosing one's look

Coco Chanel had a very strong sense of what was elegant. She knew that people were individuals and advised them to dress accordingly, but she also believed a few universal truths about fashion choices. Coco had a definitive individual look, and she often wore her own signature pieces, which meant her personal style became an extension of the Chanel brand.

The best colour
in the whole world
is one that looks
good on you.

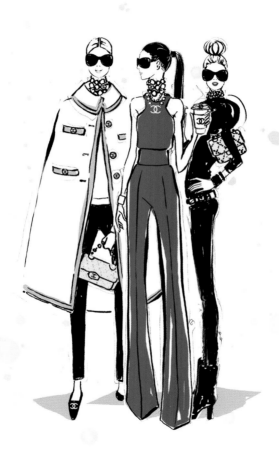

Dress shabbily
and they remember
the dress; dress
impeccably and
they remember
the woman.

It is *always* better to be *slightly* underdressed.

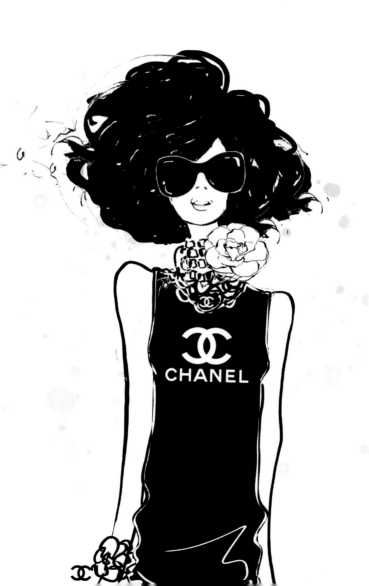

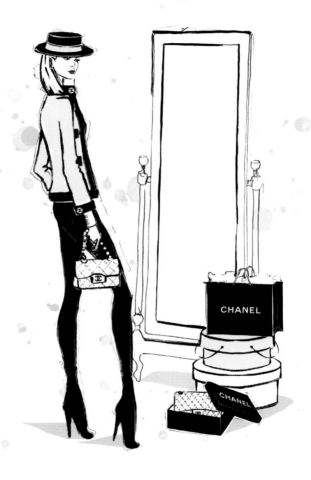

50

Before you
leave the house,
look in the *mirror*
and take one
thing *off.*

A woman
with good
shoes is
never ugly.

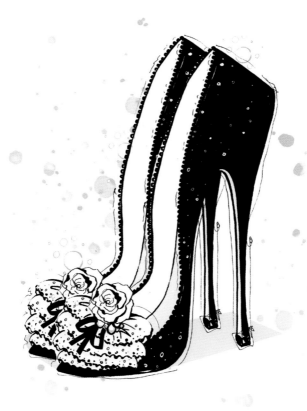

A woman who
cuts her *hair*
is about to
change her life.

Nature gives you the
face you have at 20.
Life *shapes* the
face you have at 30.
But at 50 you get
the face you *deserve*.

Simplicity
is the *keynote*
of all true
elegance.

On luxury

Having had a stark childhood with very few physical comforts, Coco Chanel connected luxury with freedom. She changed high fashion, breaking women out of corsets and creating clothes they could move in. She saw this element of her designs as a true form of luxury.

Luxury must
be comfortable,
otherwise it is
not luxury.

There are
people who
have money and
people who
are rich.

Luxury is a
relaxation
of the soul.

The best things
in life are free.
The second
best are very
expensive.

Some people
think luxury is the
opposite of poverty.
It is not.
It is the opposite
of vulgarity.

A woman can
be overdressed
but *never*
over *elegant*.

Elegance
in a garment
is the freedom
of movement.

On

Coco

Chanel

Coco Chanel was a vivid, brilliant fashion revolutionary. She knew the impact she had on the world around her and understood her place as a leader. She often used her witty turns of phrase to describe her strengths and successes. These phrases might be read as arrogant, or perhaps they were clear-eyed self-confidence. Either way, I find them charming!

I don't
do fashion.
I am fashion.

She made every woman look entirely unlike the women of the past.

**CECIL BEATON,
FASHION PHOTOGRAPHER**

In my
own way,
I made
fashion
honest.

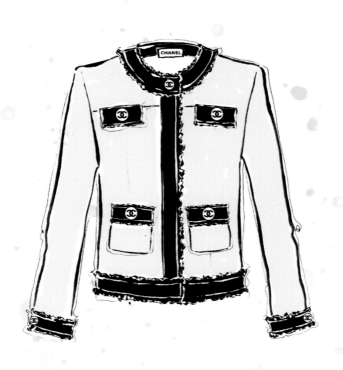

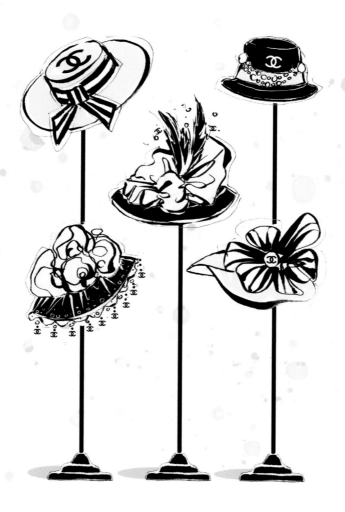

I don't *like*
to hear about
the Chanel
fashion.
Chanel is,
above all,
a *style.*

I out-fashion
fashion.

My life didn't
please me,
so I *created*
my life.

I dressed
the universe.

If I built
aeroplanes,
I would begin
by making
one that was
too beautiful.

On
relationships

Coco Chanel brought charm, wit and strength to her relationships with others. In some ways, she defied social norms, and nonetheless was able to move among the elite, which required a mix of inner fortitude, generosity and audacious elegance. She never married, but over her lifetime, had significant partners, many of whom remained close friends until her death.

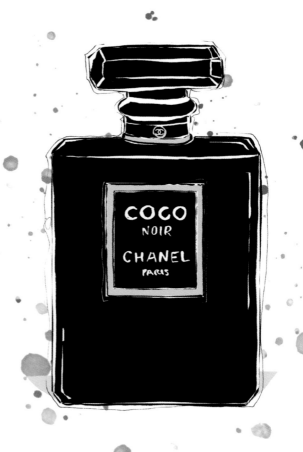

Real generosity
is to accept
ungratefulness.

After refusing the hand in *marriage* of the Duke of Westminster, Coco said, 'There have been *several* Duchesses of Westminster. There is *only* one Chanel.'

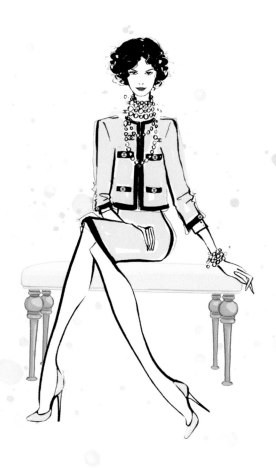

You do not know,
dear Chanel, how
shadows reflect *light*;
and it is from
the *shadows* that
I nourish such
Tenderness for you.

**PIERRE REVERDY,
POET**

She was extraordinary.
The alertness of
the woman! The charm!
You would have fallen
in love with her.
She was mesmerising,
strange, alarming, witty ...
you can't compare
anyone with Chanel.

**DIANA VREELAND,
FASHION EDITOR**

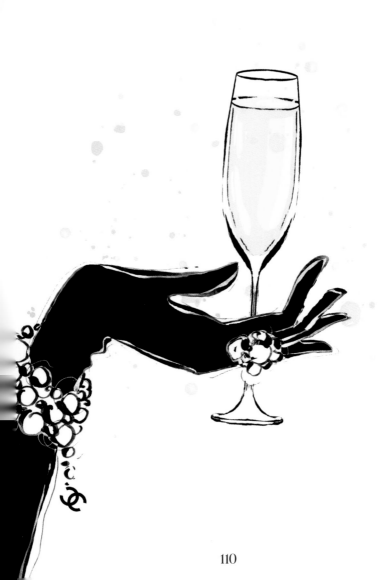

I only drink champagne on two occasions: when I am in love and when I am not.

Dress like
you are going
to meet your
worst enemy
Today.

You live
but once;
you might
as well be
amusing.

Fashion has two purposes: comfort and love. Beauty comes when fashion succeeds.

On
personal
strength

Coco Chanel understood the importance of being driven by one's own vision, rather than by the visions of others. She lived through difficult times and learnt to draw on her personal strengths. She carved out a place for her uniqueness, making a virtue out of difference, and she encouraged others to do the same.

In order to be *irreplaceable,* one must *always* be different.

The most *courageous* act
is still to think
for *yourself.*
Aloud.

Our *homes*
are our prisons:
one *finds*
liberty in their
decoration.

One can get
used to ugliness
but *never* to
negligence.

Elegance
is refusal.

Success is often achieved by those who don't know that failure is inevitable.

I don't care
what you
think of me.
I don't think of
you at all.

To achieve great things, we must first dream.

Thank you

To Jasmin Chua for jumping onto a moving train
and creating our first book series together!
The first of many more wonderful books to come.

An enormous thank you to Staci Barr, who
has meticulously worked on every single page of
this book to help bring it to life.

To Martina Granolic for your never-ending enthusiasm.

To Ailsa Wild for researching every single quote
and interesting fact about our icons – you could
also work for the FBI!

To Murray Batten for bringing everything together and
creating such a joyful and elegant design for this series.

To Todd Rechner for your incredible care and
perfection in seeing all my books to their finished form.

To my husband Craig and my children Gwyn
and Will for being my biggest inspiration.

About the author

Megan Hess was destined to draw.

After working in graphic design and art direction, Megan illustrated Candace Bushnell's bestselling book *Sex and the City* in 2008. Her career in fashion illustration has since seen her creating for renowned clients all over the world, including portraits for *Vanity Fair*, animations for Prada in Milan, the windows of Bergdorf Goodman in New York, and live illustrating for fashion shows such as Christian Dior Couture. Megan is the author of many bestselling fashion books and two sensational series for children: *Claris: The Chicest Mouse in Paris* and *Young Queens Collection*.

Visit Megan at meganhess.com

Published in 2025 by Hardie Grant Books,
an imprint of Hardie Grant Publishing
Hardie Grant Books (Melbourne)

Wurundjeri Country
Building 1, 658 Church Street
Richmond, Victoria 3121

Hardie Grant North America
2912 Telegraph Ave
Berkeley, California 94705

hardiegrant.com/books

Hardie Grant acknowledges the Traditional
Owners of the Country on which we work,
the Wurundjeri People of the Kulin Nation
and the Gadigal People of the Eora Nation,
and recognises their continuing connection
to the land, waters and culture. We pay our
respects to their Elders past and present.

A catalogue record for this
book is available from the
National Library of Australia

Words from a Fashion Icon: Coco Chanel
ISBN 978 1 76145 133 1
ISBN 978 1 76144 248 3 (ebook)

10 9 8 7 6 5 4 3 2 1

Publisher: Jasmin Chua
Project Editor: Antonietta Anello
Researcher: Ailsa Wild
Creative Director: Kristin Thomas
Designer: Murray Batten
Head of Production: Todd Rechner
Production Controller: Jessica Harvie

Colour reproduction by
Splitting Image Colour Studio

Printed in China by Leo Paper Products LTD.

MIX
Paper | Supporting
responsible forestry
FSC® C020056

The paper this book is printed on is from
FSC®-certified forests and other sources.
FSC® promotes environmentally responsible,
socially beneficial and economically viable
management of the world's forests.

Every effort has been made to ensure that
the information in this book is accurate
at the time of going to press. The publisher
welcomes information and suggestions for
correction and improvement. All trademarks,
copyright, quotations, company names,
registered names and products used or
cited in this book are the property of their
respective owners. This title is not affiliated
with or endorsed by any person or entity.
In the research for this book, quotes have
been stated in various sources:

Newspapers and magazines: *BBC Travel,
Fashion and Law Journal, Harper's Bazaar, The
New Yorker, Runway Magazine, Vogue, Vogue
France, Woman and Home;* **Books:** *The World
of Carmel Snow,* by Mary Louise Aswell,
1962; *The Little Book of Chanel,* by Emma
Baxter-Wright, 2017; *The Glass of Fashion,*
by Cecil Beaton, 1954; *Chanel and Her World:
Friends, Fashion and Fame,* by Edmonde
Charles-Roux, 2005; *Christian Dior and I,*
by Christian Dior, 1957; *Mademoiselle Coco
Chanel and the Pulse of History,* by Rhonda K.
Garelick, 2000; *Coco Chanel: The Illustrated
World of a Fashion Icon,* by Megan Hess, 2015;
The Allure of Chanel, by Paul Morand, 2009;
Coco Chanel the Legend and the Life, by Justine
Picardie, 2017; *Christian Dior: The Man who
Made the World Look New,* by Marie France
Pochna, 1996; *Sleeping with the Enemy,* by Hal
Vaughan, 2012; *Diana Vreeland - The Eye Has
To Travel,* by Lisa Immordino Vreeland, 2001;
Fashion Visionaries, by Linda Watson, 2015.